POCKET GUIDES

FLOWERS AND FRUIT

Celia Fisher

NATIONAL GALLERY PUBLICATIONS LONDON

DISTRIBUTED BY YALE UNIVERSITY PRESS

This publication is supported by
The Robert Gavron Charitable Trust

THE POCKET GUIDES SERIES

OTHER TITLES
Allegory, Erika Langmuir
Conservation of Paintings, David Bomford
Frames, Nicholas Penny
Landscape, Erika Langmuir
Faces, Alexander Sturgis

FORTHCOMING TITLES
Angels, Erika Langmuir
Colour, David Bomford and Ashok Roy
Impressionism, Kathleen Adler
Saints, Erika Langmuir

PICTURE CREDITS
70. By kind permission of His Grace The Duke of Westminster OBE TD DL.
72. National Trust, Ham House, © V&A Picture Library.
79. All rights reserved © Museo del Prado, Madrid.

Front cover: Details from *The Arnolfini Portrait* by Jan van Eyck [35]
and *The Virgin and Child in the Garden* in the style of Martin Schongauer [48]
Title page: Detail from *Fruit, Flowers and a Fish* by Jan van Os [76]

First published in Great Britain in 1998 by
National Gallery Publications Limited
St Vincent House, 30 Orange Street, London WC2H 7HH

ISBN 1 85709 239 2

525286

British Library Cataloguing-in-Publication Data.
A catalogue record is available from the British Library.
Library of Congress Catalog Card Number: 98-67956

Edited by Rosemary Amos and John Jervis
Designed by Gillian Greenwood
Printed and bound in Germany by Passavia Druckservice GmbH, Passau

CONTENTS

FOREWORD

The National Gallery contains one of the finest collections of European paintings in the world. Open every day free of charge, it is visited each year by millions of people.

We hang the Collection by date, to allow those visitors an experience which is virtually unique: they can walk through the story of Western painting as it developed across the whole of Europe from the beginning of the Renaissance to the end of the nineteenth century – from Giotto to Cézanne – and their walk will be mostly among masterpieces.

But if that is a story only the National Gallery can tell, it is by no means the only story. The purpose of this new series of Pocket Guides is to explore some of the others – to re-hang the Collection, so to speak, and to allow the reader to take it home in a number of different shapes, and to follow different narratives and themes.

The wide variety of faces to be met on the walls of the Gallery raises fascinating questions about the intentions of the artists who have tackled human physiognomy over the centuries, about how they have conveyed the personalities of their subjects, and about how we, in turn, interpret characteristics and expressions. Flowers and fruit are as universal in their appeal as the human face, and they too are to be found in profusion throughout the Collection. Perhaps less immediately accessible to us today are the messages they were intended to communicate to the viewer, who can trace their changing symbolism, as well as the development of many of their species, whether instantly recognisable or unfamiliar.

These are the kind of subjects and the questions the Pocket Guides address. Their publication, illustrated in full colour, has been made possible by a generous grant from The Robert Gavron Charitable Trust, to whom we are most grateful. The pleasures of pictures are inexhaustible, and our hope is that these little books point their readers towards new ones, prompt them to come to the Gallery again and again and accompany them on further voyages of discovery.

Neil MacGregor, DIRECTOR

INTRODUCTION

If a modern artist were to decorate his work with cannabis leaves it would be clear to all those who recognised them that some meaning was intended. The interpretation of that meaning would depend on whether the context were peaceful, colourful or macabre; on how the viewer felt about drugs; and on how noticeable and identifiable the plant was. Above all it would be a plant of our times – relevant and thought-provoking.

Many paintings in the National Gallery contain plants whose significance is as straightforward as their beauty, while in others the artist's intentions are obscure. Roses may be sacred, romantic or simply roses – but they can also be sarcastic. Apples are appropriate for characters as diverse as Eve, the Virgin Mary, Venus or a witch; and when apples appear in a still life of a bowl of fruit our minds are free to wander over all these possibilities – although to a gourmet or a gardener the variety of the apple might be of keener interest. This book is also intended for those who appreciate that, in their day, striped tulips, yellow hollyhocks and pineapples were very rare indeed.

1. Detail from *A Basket of Roses*, 1890, by Ignace-Henri-Théodore Fantin-Latour.

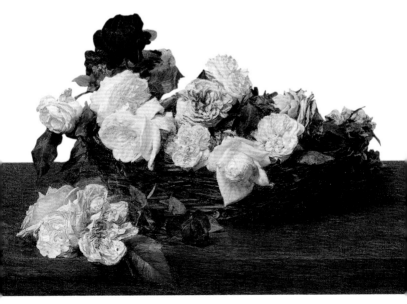

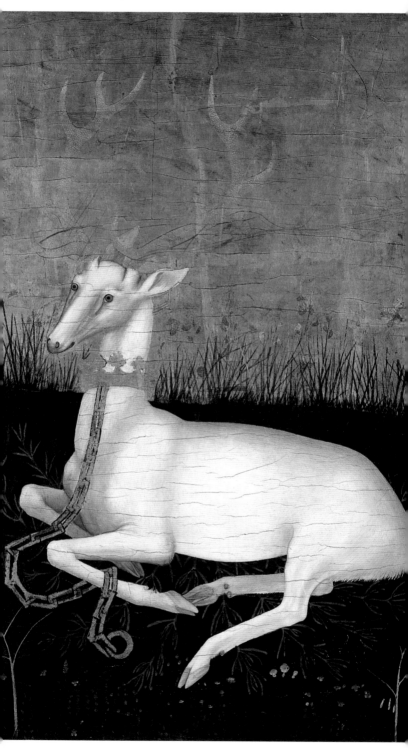

SCATTERED FLOWERS
AND FLOWERY MEADOWS

The earliest painting in the National Gallery to set the scene among flowers is *The Wilton Diptych* [2], and it introduces us immediately to their complexity. They exude meaning as powerfully as the rosemary bush on which the white hart is sitting must be exuding fragrance [3]. The Elizabethan herbalist John Gerard wrote that the smell of rosemary: 'comforts the cold, weak and feeble brain in a most wonderful manner.' As a doctor he was endorsing the ancient practice of Greek and Roman scholars who twined garlands of rosemary in their hair to dispel gloom and to help them concentrate; but over the centuries 'rosemary for remembrance' had gathered romantic overtones. As a festive plant it was worn at weddings and it was cast onto graves by mourners. Shakespeare neatly gave it both meanings in *Romeo and Juliet* (Act IV: scene v). The rosemary in *The Wilton Diptych* was a personal emblem of Anne of Bohemia, Richard II's much-loved queen, while the white hart was the emblem that represented Richard himself. Anne's death some years before the completion of *The Wilton Diptych* means that the plant here bears the full

2. The interior of *The Wilton Diptych*, about 1395–9.

3. The exterior of the left wing of *The Wilton Diptych*: *The White Hart*, about 1395–9, showing branches of rosemary, bracken, forget-me-not, speedwell and Adonis flowers.

7

weight of its romantic and mourning attributes, since it stands for a precious memory.

The rosemary in *The Wilton Diptych* has also aroused the interest of garden historians. Although it grows wild in Mediterranean countries, there is no record of it growing in medieval England before 1338. That year Queen Philippa, newly married to Edward III, received some cuttings from the Netherlands with a little note from her mother the Countess of Hainault, suggesting that sprigs of rosemary under the pillow might help to keep her husband faithful. While they failed to ensure this, the propagation of the cuttings was successful, and the large bush in her grandson's Diptych is a visual record of this horticultural success.

Other plants in *The Wilton Diptych* also commemorate Anne of Bohemia. The little blue and red blossoms in the white hart's meadow may well be forget-me-not, speedwell and Adonis flowers, all of which have associations with lost love. Framing the foreground are two bracken plants – unusual but appropriate – since descriptions of the jewellery of the dead Queen show that she used ferns as her device, as well as rosemary. In the panel of the Virgin [4], there is another, daintier fern – most like maidenhair – on the far right between the blue robes of the angels. These leaves could certainly inspire jewels for a queen; but maidenhair was also, as the name implies, associated with the Virgin. As was rosemary, whose white flowers were said to be tinged with blue since the time she hung her robe over a bush to dry in the sun. Indeed, towards the end of the Middle Ages, the new excitement that artists felt in depicting plants realistically, and that herbalists felt in detailing their medicinal properties, was matched by an encyclopaedic folklore of their religious associations.

4. Detail of 2, including violets, roses, daisies and maidenhair fern.

During the century after *The Wilton Diptych* was produced, gardens became a natural setting for paintings of the Virgin and Child, evoking thoughts of Paradise and the Garden of Eden, as well as real gardens and their plants. However, in *The Wilton Diptych* the largest flowers are not growing, but plucked off and scattered – an act of homage emphasised by the fact that half the roses are upside-down and the violets are lying at such curious angles that they are hard to recognise. Also the original bright colours of the paint have changed over the centuries. The roses would have been deep red *Rosa gallica* and pure white *Rosa alba*; semi-double ancestral roses retaining their central stamens and therefore their fertility; the roses of heraldry and the Wars of the Roses; the major if not the only roses cultivated in England before the sixteenth century. They also adorn the angels' heads; and here again the inventories of Richard II's treasures add evidence on the plants, listing chaplets of enamelled red and white roses, made to be worn in processions. Both the wearing and the scattering of flowers were part of the pageantry of the Middle Ages. During the celebrations of Whitsun, showers of rose petals were used to represent the Holy Spirit descending on the disciples; and for the Feast of the Annunciation in March, the image of the Virgin would have been surrounded with violets. The language of symbolism explained that the scent of violets reflected her sweetness, their purple colouring her suffering and their gently drooping heads her humility. (Incidentally, with these important symbolic flowers, *The Wilton Diptych* is probably the first of many paintings to set the flowers or fruits of different seasons side-by-side to satisfy an artistic purpose; and in so doing, to ignore their relative sizes.)

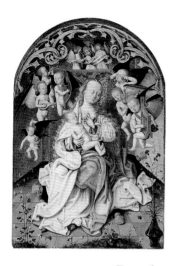

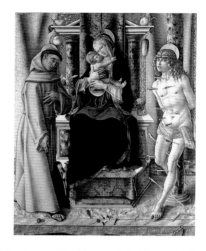

5. Master of the Saint Bartholomew Altarpiece, *The Virgin and Child with Musical Angels*, probably mid-1480s.

6. Carlo Crivelli, *The Virgin and Child with Saints Francis and Sebastian*, 1491.

Two other paintings in the National Gallery which show flowers strewn before the Virgin and Child were done almost a hundred years later, and help to confirm how widespread the ceremony was. The German Master of the Saint Bartholomew Altarpiece again surrounds them with angels, but this time in an interior, where the cool architectural surroundings emphasise the fragility of the little, cast-down petals – as if this quality were itself a metaphor for the mortality of Christ [5, 7]. Certainly the white and yellow stocks (which are members of the plant family

7. Detail of 5, showing columbines, stocks, daisies, strawberries and cornflowers.

named *Cruciferae* because they have four petals in the form of a cross, instead of the more usual five petals) foreshadow the suffering on the cross. The columbines, which are shown both scattered and growing, were mournful flowers – purplish-blue, like violets – with the French name *ancholie* which signifies melancholy. They were often associated with bereavement and especially with the sorrow the Virgin herself was to suffer when Christ was crucified. Strawberries, on the other hand, since they had no stone or thorn, were taken to symbolise the pure sweetness of the Virgin – although they may also, in the context of this painting, represent drops of Christ's redeeming blood. In fitting contrast, daisies were used in balms for wounds; but the intended link again may be with the Virgin herself, since daisies are the only flower to occur in each of the three paintings where flowers are scattered at her feet – among the roses and violets of *The Wilton Diptych*, and in *The Virgin and Child with Saints Francis and Sebastian* by the Venetian artist Carlo Crivelli [6, 8]. Here, even more, the hard stone casts the brave colours of the flowers into relief, and their variety might cause the sceptic to question whether each one must bear an individual meaning. Must the red of the poppy always be linked with blood, or its sleep-inducing qualities with death? Is the

bindweed here because it looks like a little bell? Do the marigolds have similar meanings to the daisies or are they there because of their contrasting golden colours? Marigolds were much used for garlands in summer festivities but they were also laid on graves. Like other members of the *Compositae* family they healed the infections of wounds and fevers. One thing is certain; these flowers were not chosen for their rarity value – all except the rosebuds could be troublesome weeds.

8. Detail of 6, showing rosebuds, daisies, marigolds, poppy and bindweed.

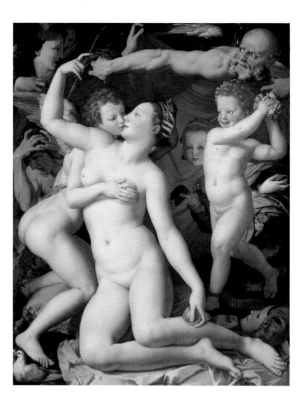

The strewing of flowers has an ancient history,
and although the Virgin and saints had supplanted
the old gods, the latter retained their fascination and
their symbols. Originally roses were the voluptuous,
sweet-scented flowers of Venus; and for her they are
scattered again in the paintings of Bronzino [9] and
Tiepolo [10]. And this brings us to the irony of which
flowers are capable. One of the central images of Jan
Steen's disorderly family in *The Effects of Intemperance*
[11] is the son and heir throwing roses in front of a
pig, a troubling perversion of the old reference – the
Biblical 'casting pearls before swine' (Matthew 7: 6)
having been adapted into a Dutch proverb using roses
instead of pearls.

The many attributes allotted to plants blurred the
distinction between wild flowers and garden flowers.
Besides, a flowery meadow was suitable not only for
the Virgin and saints, but could as well be the setting
for a hunting scene. Thus Saint Giles (rescuing his
wounded deer from the king's arrows) [12], or the
pleasure-loving Saint Hubert (converted by a vision
while out hunting) [13], or Piero di Cosimo's Satyr

12

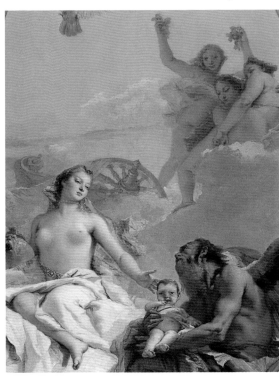

10. Venus with the Three Graces, detail from *An Allegory with Venus and Time*, about 1754–8, by Giovanni Battista Tiepolo.

11. Detail from *The Effects of Intemperance*, about 1663–5, by Jan Steen.

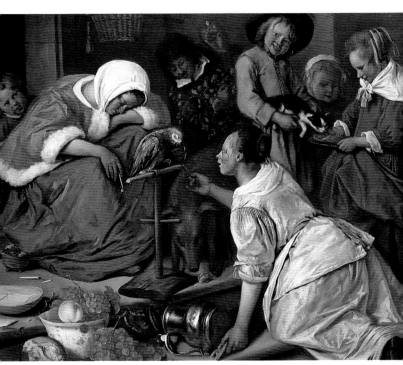

12. Master of Saint Giles, *Saint Giles and the Hind*, about 1500.

13. Workshop of the Master of the Life of the Virgin, *The Conversion of Saint Hubert*, probably about 1480–5.

14. Detail of 12 showing rose, iris, mullein and cinquefoil.

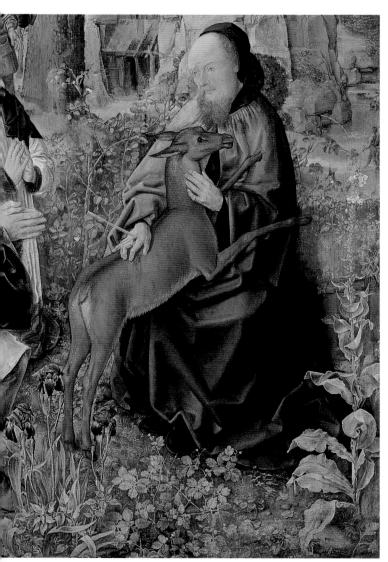

(mourning over a Nymph killed by a hunting spear), are all surrounded by flowers. Probably none of these flowers was chosen randomly, and several were included for their healing properties. The tall spire of yellow-flowered mullein beside Saint Giles [14] was often likened to a hedgerow candle (and its fibres were used as wicks); but the thick, downy leaves – here so prominent – could be made into a poultice to 'draw forth speedily thorns or splinters gotten into the flesh' (as John Gerard said in his Herbal). Centuries earlier the Elder Pliny, a Roman author who included botany in his encyclopaedic works, had attributed the same properties to the roots of the mallow plant which has been placed beneath the kneeling king; while the cinquefoil under Saint Giles would staunch the bleeding and soothe the inflammation. If these plants should be read as a code of healing, are others part of the wounding? The thorns of the white rose bush and the sharp-pointed leaves of the iris both had these attributes in religious art and commentary – made more poignant by the beauty of the flowers. But the tiny blue bellflower (*Campanula sp.*) beside the iris is puzzling; campanulas are very rare in art, in spite of their folklore associations. They neither inflict nor cure wounds. Perhaps, like the bindweed, they evoke the sound of bells because of their shape.

The plants around Saint Hubert give a more straightforward message [15], representing the wayside where this definitive moment in his life has taken place. Plantains, dead nettles and ferns were a natural choice for artists as far apart in time and

15. Detail of 13, showing white dead nettle, plantain, lily of the valley and cinquefoil.

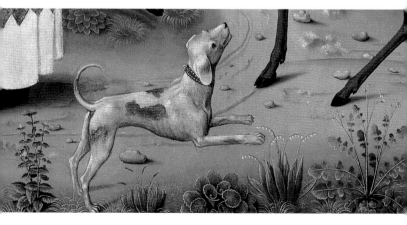

16. Detail from *The Adoration of the Kings*, 1500–15, by Jan Gossaert, showing a white dead nettle.

17. Gerard David, *The Adoration of the Kings*, 1515–23.

18. Piero della Francesca, *The Nativity*, 1470–5.

19. Detail of 17, showing ferns and plantain.

place as Masaccio and Gossaert [16]. Growing through cracks in stones, they emphasise the weedy and neglected places where saints trod through the wilderness or fought the devil; or the ruined stable where Christ spent his first days on earth, where Gerard David shows ferns growing on the walls [17, 19]. Thistles were another obvious choice. Piero della Francesca, with exquisite realism, showed a goldfinch about to feed on thistledown [18, 20] and

20. Detail of 18, showing thistles and goldfinches.

Bartolomé Bermejo chose an elegant eryngium for the foreground of Saint Michael's *coup de grace* [21, 22] – spiked like the devil and reflecting the other metallic colours in the painting (just as the poppy reflects the devil's blood-red eyes).

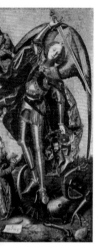

21. Bartolomé Bermejo, *Saint Michael triumphant over the Devil with the Donor Antonio Juan*, about 1468.

22. Detail of 21, showing eryngium and poppy.

This early impulse towards botanical realism, inspired as it was by a fascination with the uses and meanings of plants, was matched at the birth of twentieth-century art by Van Gogh's search to express the life forces of nature through plants. During the summer of 1888 in Arles, he wrote of the beautiful sun of midsummer beating upon his head and the colours which caused each other to shine more brilliantly. He too was driven by a religious fervour and assumed that his paintings would speak directly and vividly for themselves: 'Oh I know very well that not a single flower is drawn completely, that they are mere dabs of colour – but the impression of all these colours in their juxtaposition is there all right, in the paintings as in nature.' (Letter W5.) Like his forebears, Van Gogh was concerned not only with the great beauty of irises and roses, but with the significance of wayside plants. He was much struck with the concept of the Japanese artist seeking enlightenment in a single blade of grass; and during the same summer that he was painting sunflowers he wrote twice about 'Thistles in a wasted field ... I am working on another

study of dusty thistles with an innumerable swarm of white and yellow butterflies'. (Letters 522 & 526.)

It is a popular misconception that those who love flowers have chosen something pretty and easy with which to enrich their lives. This was not how Van Gogh saw them, and not why fifteenth-century painters used them. By the following summer Van Gogh was in the asylum at St-Rémy, unable to go beyond 'the abandoned garden' where 'the grass grows tall and unkempt and mixed with various weeds'. (Letter 592.) But the plants inspired him, and in May 1890, after two months of total breakdown, he wrote again 'as soon as I got out into the park I got back all my lucidity for work ... two canvases of the fresh grass in the park ... the grass with white flowers and dandelions'. (Letters 630 & 631.) The way Van Gogh has captured the sun and the breeze in the grass and the hovering butterflies is unique [23]; but although colour and movement were his main concern, Van Gogh would have appreciated the response of those whose eyes wander through the grass stalks, imagining that as well as dandelions there are mayweeds, poppies and plantains. For to endow these plants with names and meanings is a reciprocal effort dependent on the viewer as well as the artist.

23. Detail from *Long Grass with Butterflies*, 1890, by Vincent van Gogh.

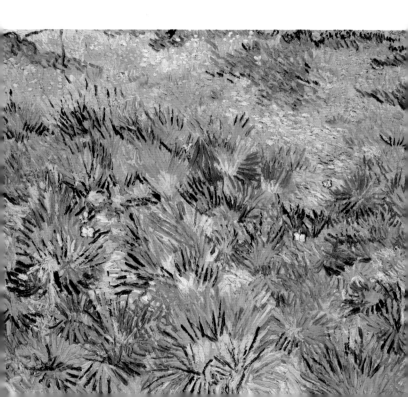

FLOWERS AND FRUIT OF THE RENAISSANCE

Of all the flowers in the National Gallery, none goes through such a dramatic visual development as the carnation; and this exactly reflects its horticultural progress between the fifteenth and seventeenth centuries. It was originally named dianthus – flower of the gods – by the Greek botanist Theophrastus, implying that in classical times it was considered lovely enough to have sacred attributes; and it is from a species that grows wild in Mediterranean countries – *Dianthus caryophyllus* – that cultivated carnations and pinks mainly derive. However, unlike many other traditional plants, carnations do not feature in the records of medieval gardens – even in Italy or Spain – until late in the fourteenth century. By that time Friar Henry Daniel (who also recorded the arrival of the first rosemary plants in England) had grown one in his garden, 'at Stepney beside London … and thither it was brought from Queen Philippa's herber. It is wondrous sweet, and spiceth every liquor that it be laid in.' He called it *garofila*, a variant of the Italian *garofano*,

24. Carlo Crivelli,
*The Immaculate
Conception*, 1492.

25. Details of 24,
showing roses,
carnations and
lilies.

26. Detail from *La Madonna della Rondine* *(The Madonna of the Swallow)*, about 1490–2, by Carlo Crivelli.

which means both cloves and carnations, and which is the origin of the old name gillyflower. These words for pinks and carnations have the same derivation as cloves because they are related botanically and share the same heady scent. Both were used as 'sops in wine' to hide the tendency of medieval alchohol to turn sour.

What's in a name? There was clove gillyflower to convey its scent and shape, and dianthus for its sacred attributes; while carnation – from the Latin *carnus* for flesh – was used to describe the colour of the flower, which in its natural form is nearly always pink. This explains why carnations, or pinks, appear so often in late fifteenth-century paintings of the Virgin and Child: 'and the word was made flesh and dwelt among us.' (John 1: 14.) Such play with words, concepts and symbols was much appreciated, and the Immaculate Conception of the Virgin, the doctrine that she herself was born without the stain of Original Sin, is recorded by the Venetian artist Crivelli, who shows Mary flanked by vases of the most appropriate flowers: white lilies for her purity, roses to honour her, and carnations which recall the Incarnation of Christ and her role as his mother [24, 25].

Crivelli uses pinks again, depicting them them with great naturalism growing in a terracotta pot, in the *Madonna della Rondine (The Madonna of the Swallow)* [26, 33]. Swallows became symbols of the Resurrection because they were believed to hibernate in mud; and Crivelli has placed the pinks alongside the swallow to represent the Incarnation and the Resurrection of Christ. But no painting shows more clearly how, alongside the meanings that plants might bear, their natural forms and variations have capti-vated the artist's eye and led to an act of observation and recording that would gladden the heart of a

21

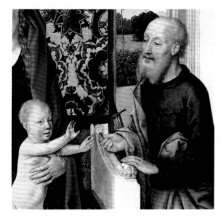

botanist. The pinks in Crivelli's terracotta pot also prove that by the end of the fifteenth century the normal colour of wild pinks had been extended to red and white by the selection of cultivated forms. Indeed, the works of other artists besides Crivelli suggest there was a growing interest in the colour variations of flowers – for instance, the Master of the Saint Bartholomew Altarpiece's columbines are both blue and white, and his cornflowers blue and pink [7].

Another example of the development of the white carnation appears in *The Virgin and Child with Saints Peter and Paul* by the Netherlandish artist Dieric Bouts [27]. Here Saint Paul is offering the flower to the Child, who reaches eagerly towards it. There is an intriguing contrast in the German painting by a follower of Schongauer, where the Child is cringing away from the carnation that is offered to him [28, 48]. Do the flowers convey different messages, or different reactions to the same message? Another widespread European name for pinks meant nail-flower (and here again there was a link with cloves which comes from the Latin *clavus* for nail). In the days when nails were hand-forged, and the heads beaten out like metallic petals, the resemblance between the dried spices, little wild pinks and nails was striking, and led to an association with the nails with which Christ was crucified. Even in Crivelli's *The Immaculate Conception* [24], it is likely that the three carnations also contain this meaning, since many paintings of the Virgin and Child contain elements of their future suffering. Sometimes this is overcome by the joy and tranquillity of the scene; but sometimes it causes grief and foreboding.

An early double carnation features in Andrea Solario's *A Man with a Pink* [91], the fluffy delicacy of its pink petals contrasting oddly with the implacable stare of its owner – especially since carnations held in portraits were generally love-tokens, signifying a marriage or betrothal. When the Austrian Emperor Maximilian first met his future wife Mary of Burgundy in 1477 he was told that Mary had hidden a pink in her clothes for him to find. This was supposed to be a well-known betrothal custom, but Maximilian was baffled by it until a nearby Bishop advised him to part his fiancée's clothes. But to return to horticulture, there is an example of how these early garden carnations were nurtured in the background of *The Virgin and Child in a Landscape* by Jan Provoost [29, 49]. The slender elongated stalks could barely support the

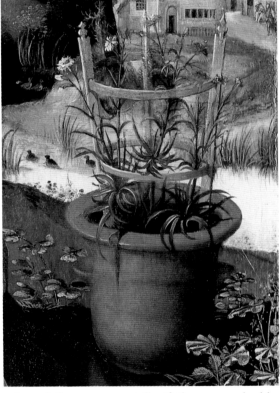

enlarged flowers, especially if they were double. Carefully constructed canes and hoops were placed around the plants, and they were cultivated in pots so that they could be moved to a prominent position when at their best, or sheltered in inclement weather

29. Detail from *The Virgin and Child in a Landscape*, early 16th century, by Jan Provoost.

23

30. Detail from *Flowers in a Glass Vase*, about 1670, by Jacob van Walscappelle.

and during the winter. All these efforts (and they *were* efforts – one contemporary gardener wrote that no plant was more inclined to die, burst its calyx or suffer from earwigs), reached their apotheosis a hundred years later when the superb blooms of the Dutch and Flemish flowerpieces flaunted their colours; now no longer simple reds and whites but alluring combinations of the two in various shades and streaks. John Parkinson, who published a Herbal in 1629, named nineteen different carnations, including the Great Harwich (which sounds as if it originated in Holland), rising up on 'a great thick round stalk, with a gallant, great, double flower with petals deeply jagged at the ends, of a deep carnation, almost red, spotted with blush spots and streaks, and an excellent soft, sweet scent'.

31. Detail from the central panel of 'The Donne Triptych', *Virgin and Child with Saints and Donors*, probably about 1475, by Hans Memling.

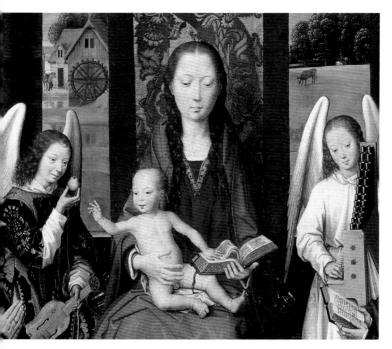

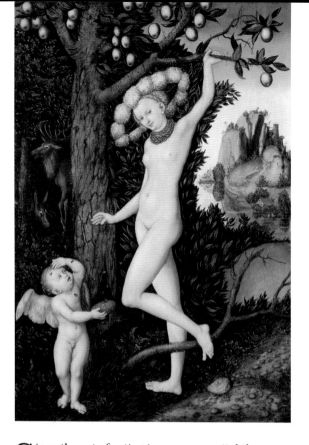

Since the act of eating is even more vital than seeing or smelling, the extra dimension this gives to fruit, and the wealth of mythology it has accumulated, gives it even more potential for artistic expression and allusion. When the Christ Child is offered a carnation, this needs some explanation; but when Memling's angel offers Christ an apple, it creates a reverse image of the Garden of Eden as immediate now as it was then [31]. When the serpent tempted Eve with the fruit of the Tree of Knowledge, Adam and Eve were alienated from God; Christ and his mother (who was often called the New Eve precisely because of her role in the history of Salvation) accepting the apple symbolises the opportunity to restore the lost relationship.

This concept is central to the imagery of apples and indeed all fruit, which is haunted by the possibility that it might be forbidden; and when Cranach painted Venus [32], resplendent in her nakedness and her elaborate hat, reaching for apples in a laden tree, she was making the same gesture as Eve at the moment of the Fall of Man, and her obvious sexual

32. Lucas
Cranach the
Elder, *Cupid
complaining to
Venus*, probably
early 1530s.

25

33. Carlo Crivelli, *La Madonna della Rondine (The Madonna of the Swallow)*, about 1490–2. The fruits include cucumber and quince (above the figures), apple (in Christ's hand) and, in the frieze, pears, grapes, peaches and hazlenuts.

allure became illicit. Whether this is enticing, disturbing or repellent depends on the viewer; but the apples play an important part in the psychodrama. Nor does the fascination of Venus' apples end there, since she too was given an apple which caused enormous trouble (in another of Cranach's favourite scenes) when three Greek goddesses appeared to Paris, Prince of Troy, competing for the golden apple. He was meant to award it to the fairest, but each goddess tempted him and Venus won by promising him another man's wife. The ill-fated decision, the

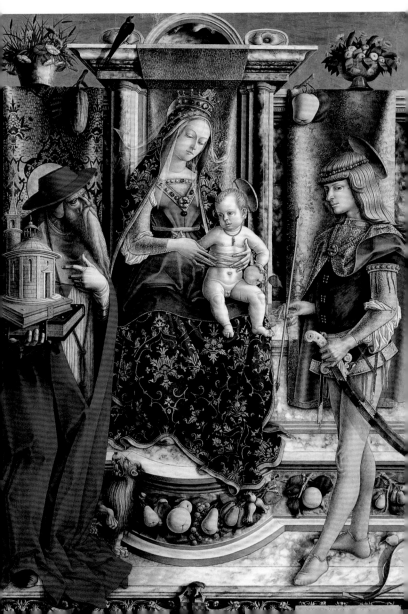

abduction of Helen of Troy, the ten years' war with Greece, were all associated with the apple of discord, which Bronzino shows clasped in Venus' hand [9].

Even for Cranach these ancient memories may not have been as light-hearted as they seem. Certainly for Crivelli the fruits that garland his paintings seem to weigh heavily with sweetness and sorrow [33, 34]. Grapes in Christian art represent the Communion wine and the sacrificial blood of Christ; but they can be the most ambiguous of all fruit. The Bible itself provides contradictory texts including 'sour grapes'

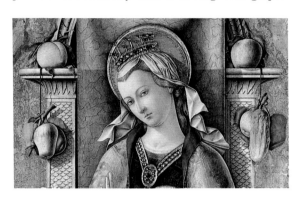

(Ezekiel 18: 2) and 'wine that maketh glad the heart of man' (Psalm 104: 14): besides which our cultural heritage includes Bacchus, Silenus and a host of revellers down the ages who have used or misused the fruits of the vine. It has been suggested that each of Crivelli's fruits bears a separate meaning, to be read like a coded message. For instance that the goodly apple symbolising redemption is juxtaposed with the cucumber which is bitter and misshapen to represent sin and particularly lust. But the Bible casts no such slur on cucumbers. They are recorded as the simple luxury for which the Israelites longed after two years wandering in the desert (Numbers 11: 5); and indeed Crivelli's cucumber may have been intended to allude to the gourd which sheltered Jonah outside Nineveh. Since he survived three days in the belly of a whale, Jonah and also his gourd became symbols of resurrection (Jonah 4: 6).

For those fascinated by the fruits themselves Crivelli offers peaches, pears and quinces, all fruits which had been brought into cultivation during early civilisations. The best peaches went from Central Asia

both eastwards and westwards along the old silk routes. In Chinese mythology they occupy a similar place to apples in ours, while their name in all European languages derives from the belief that they first came from Persia. Quinces certainly came from Persia, and in warm countries where they ripen golden, sweet and fragrant, they became synonymous with love and fertility. Indeed they have a strong claim to be the original fruit of Venus and Eve, of the amorous 'comfort me with apples' (Song of Solomon 2: 5), and the French aptly named them *pommes de paradis.*

35. Jan van Eyck, *The Arnolfini Portrait*, 1434.

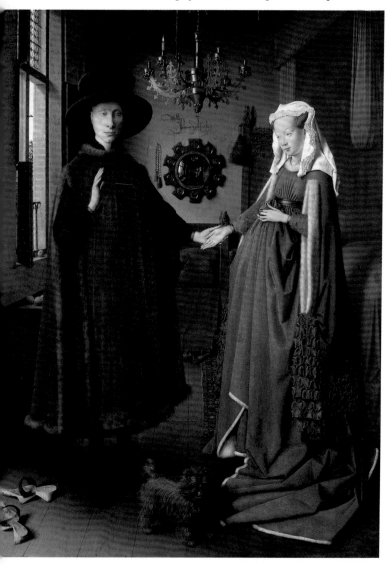

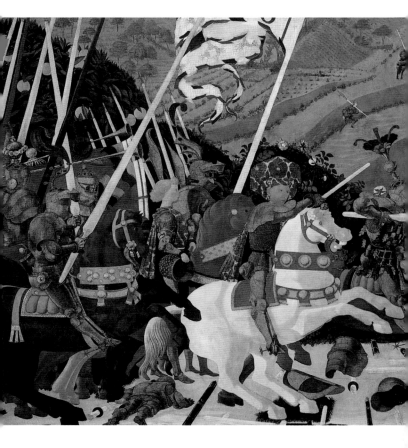

The same claim has sometimes been made for oranges, but that is anachronistic. All oranges originate from Southern China and the first to arrive were the bitter *Citrus aurantium* (now known as Seville oranges because in Europe they were cultivated in the Moorish gardens of Spain and Sicily). Oranges gained little place in Christian symbolism but became a sign of opulence, since only the rich could offer dishes flavoured with oranges or scent themselves with distillations of orange blossom. This is why Giovanni Arnolfini, as a wealthy Italian entrepreneur in Bruges, has oranges in his portrait [35]. Oranges were also reminiscent of the golden balls which were the emblems of the Medici – the great mercantile and ruling family of Florence – which may be why Uccello included them in his *The Battle of San Romano* [36], painted for the Medici palace. The oranges glow richly in the hedges 'like golden lamps in a green night' (Andrew Marvell, *Bermudas*).

36. Detail from *The Battle of San Romano*, probably about 1450–60, by Paolo Uccello.

29

37. Attributed to David Davidsz. de Heem, *Still Life*, probably late 1660s.

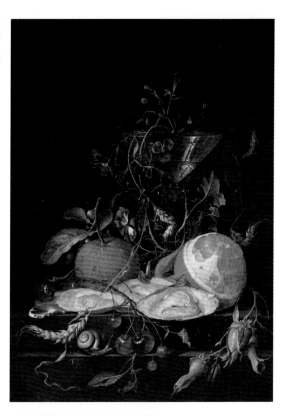

38. Caravaggio, *The Supper at Emmaus*, 1601.

39. Detail of 38, showing pomegranate, fig, grapes, apple, medlar and quince.

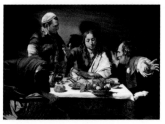

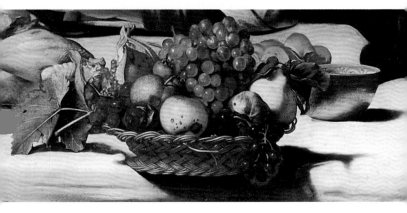

40. Joos van Cleve, *The Holy Family*, about 1515–20.

By the 1660s, when David de Heem painted his *Still Life* [37], sweet oranges (*Citrus sinensis*) had finally provided Europeans with a raw citrus fruit into which they could sink their teeth without flinching. (This was what Charles II was doing at the theatre with Nell Gwynne's oranges, although the novelty of his experience is not always appreciated.) An early consignment of sweet oranges – possibly the first – was recorded arriving at Lisbon in 1630, and by this time artists had begun to paint flowers and fruit in their own right as still lifes, rather than as adjuncts to a figurative scene. The time of transition from symbol to subject is expressed with suitable tension and drama in the basket of fruit balanced right on the edge of the table in Caravaggio's *The Supper at Emmaus* [38, 39]. Only the bread was essential to the scene of Christ's miraculous appearance just after his Crucifixion. The fruit that Caravaggio has added is varied and luscious as it would be in a still life; but the figs and pomegranates are not split open simply to show their ripe, red flesh. Like the grapes, they are there to reinforce the central

31

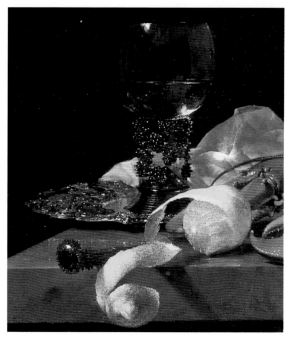

message of Christ's death and resurrection. A hundred years earlier Joos van Cleve had used the same convention with the same symbolism, cutting a precious orange and laying the knife across it to point directly at the Christ Child, and dangling cherries like drops of blood from his mother's hand [40].

The same tradition still inspired Dutch masters in the seventeenth century to place cut lemons so that their juice would catch the light and their peel would form loops of gold [41]. Although primarily a celebration of the artist's skill, the lemons still bore a bitter

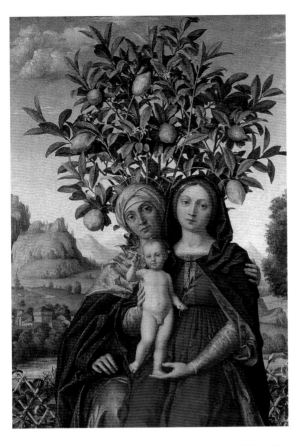

sweet message, somewhat fainter than when fifteenth-century Italian Masters associated lemons with the Virgin [43], or when cut fruit symbolised Christ's death. Possibly all still lifes carry an echo of the old meanings and we respond to the extent that we are aware of them, or find new meanings. For instance, when Gustave Courbet painted a bowl of apples, one pomegranate and one quince [42], he used a traditional theme, but he made their roundness and redness so bold and life-affirming that he heralded the concentration on colour and form later seen in Cézanne's work. But Courbet's painting still contains echoes of an older meaning. France had been plunged into the Franco-Prussian War, and Courbet himself was deeply involved in the struggles of the Paris Commune, for which he became a political prisoner. Indeed the picture may well have been painted while he was in prison. The bitter element can still be found here.

43. Detail from *The Virgin and Child with Saint Anne*, 1510–18, by Gerolamo dai Libri.

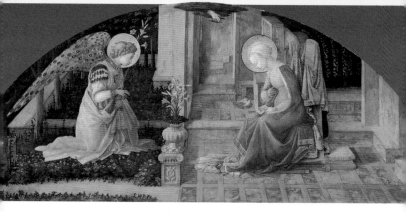

Our visual impression of the walled gardens of our ancestors, with their turf benches, vine arbours and fountains, owes much to their adoption as a setting for paintings of the Annunciation or of the Virgin and Child. The enclosed garden in medieval castles and cloisters was often named 'the paradise'. It was also a poetic symbol of Mary's virginity, taking Biblical authority from the Old Testament love song of Solomon to his bride (Song of Songs 4: 12), and rendered venerable in Latin sermons and commentaries when she was referred to as the *hortus conclusus*. Garden scenes also provided an opportunity for the artist to display the flowers and fruits which enhanced the meaning he wished to impart. Thus Fra Filippo Lippi's *The Annunciation* [44] includes a Madonna lily – the ultimate symbol of purity – growing in a handsome stone urn which has been positioned on a low wall (as prized plants often were); and the painting demonstrates how a Florentine loggia would lead into an area of flowery grass encompassed by shady trees. It is reminiscent of the *Decameron*, the Italian precursor of Chaucer's *Canterbury Tales*, where on the third day of story-telling the author Boccaccio set the scene in the garden of a fourteenth-century villa outside Florence, placing in the centre a plot of grass jewelled with a thousand flowers, set round with orange and lemon trees, and containing a fountain of white marble in which the trickle of water created a most delightful sound. Just such a fountain appears in Zanobi Strozzi's *The Annunciation* [45], and tiny daisies sparkle among the flowers in the grass. Backed by a rose-covered trellis, the surrounding walls are shown as red and stepped to give seating all round the lawn, except where a wooden gate enhances the sensation that one's eyes are exploring a real garden.

44. Fra Filippo Lippi, *The Annunciation*, late 1450s?

45. Detail from *The Annunciation*, about 1435–8, by Zanobi Strozzi.

34

In the more Northerly garden of Bruges portrayed by Gerard David, the walls are typically far higher [46]. Within them is a tunnel arbour covered with vines where an angel is picking grapes. Even without the religious overtones that associated grapes with Christ and the sacrificial wine, the vine arbour would have been a most admired feature, still retaining the sophistication of its origins in the Moorish gardens of Spain, such as the Alhambra. The lower struts form a fence for pink roses – another realistic touch, since contemporary garden roses formed sturdy hedges but were not true climbers like the vine. Within the confines of the grapes and roses there is a central area of grass with important symbolic flowers appearing between the Virgin and Saints [47]; deep purple irises and softer purple columbines; white Madonna lilies contrasted with the orange *Lilium bulbiferum*. This time the lilies reflect that fascination with variations of plant colour and form that has gripped gardeners through the ages.

Not all artists placed the Virgin and Child within a *hortus conclusus.* Another idyllic setting was the turf bench surrounded by flowers against a landscape background. Such benches were a much-loved part of a herber, planted with low-growing, vigorous, sweet-smelling flowers such as appear in the paintings:

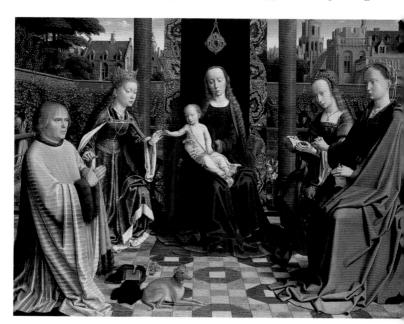

47. Details of 46 showing irises and lilies.

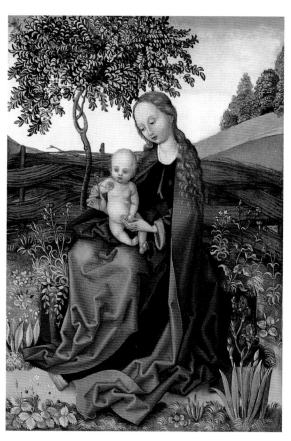

lilies-of-the-valley, strawberries and violets. (Artists
also included those all-too-familiar denizens of grass
– plantain, dandelions and daisies – which were more
acceptable in medieval lawns than they are now,
especially since they were all considered to have med-
icinal qualities.) The follower of Martin Schongauer
has added irises, stocks, campions and a carnation,
from which the Virgin has plucked a flower [48]. Jan
Provoost has also chosen a carnation as his most
important flower, placing it on the turf bench where
the details of its blooms, its terracotta pot and the
wooden supports with carved tops can all be admired
[49]. Other realistic details – besides the delightful fly-
ing toy with which the Child is playing – include the
wooden planks supporting the turf bench and the
fence tied together with ropes.

Within the confines of the garden setting there
were significant variations. An Italian master was
naturally more likely to place the Virgin in a bower

consisting of lemon and pistachio trees [51], or to include fragrant Mediterranean plants such as jasmine and musk roses in a bowl of flowers [50]. The German follower of Dürer created a gothic wall for his *hortus conclusus*, ruined and romantic, with an arched recess to show a seascape beyond, although his turf bench, vine and rustic wooden supports are reassuringly traditional [52]. German painters were especially inclined to chose peonies as a flower of the Virgin, possibly because they best expressed the

49. Jan Provoost, *The Virgin and Child in a Landscape,* early 16th century.

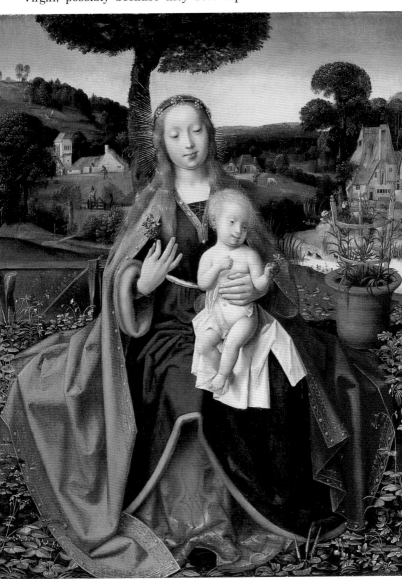

50. Detail showing jasmine and musk roses from *The Virgin and Child with Saint John*, 1475–80, by Filippino Lippi.

51. Andrea Mantegna, *The Virgin and Child with the Magdalen and Saint John the Baptist*, probably 1490–1505, showing lemons behind the Virgin and pistachios behind Saint John.

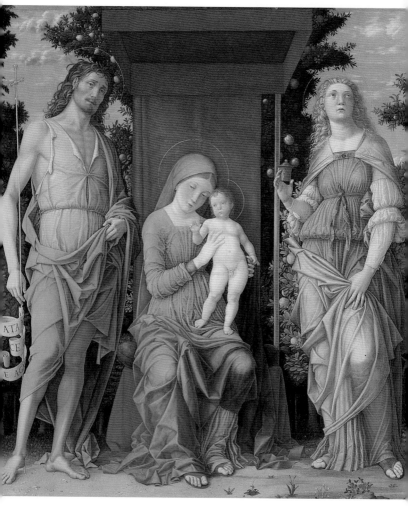

poetic description of 'a rose without a thorn'. Peonies, like roses, were originally an attribute of a Greek deity – in this case Apollo – and like irises, they were first introduced to Northern Europe during the Roman Empire. The double peony had yet to be developed, but, while the pale colour of the flower may be a result of faded pigment, it might also demonstrate an interesting variation on the normal deep red. The iris is also a curious form, unusually tall and pale with compact petals; it has been disputed whether it is a variety of *Iris germanica* or a different species, but it is certainly a prelude to the diversity of iris hybrids in seventeenth-century Holland, which at last contained all the colours of the rainbow after which irises were originally named.

In art irises have been great rivals to roses. They have been depicted curving sinuously on the walls of the ancient Cretan palace of Knossos and, nearer our own time, in Art Nouveau decorations. They have appeared stiff and heraldic in the *fleur de lys*; fragile in Japanese prints and screens; and brilliant in Persian miniatures. In the National Gallery irises appear from the earliest paintings – there are yellow water irises (faded now) against the golden background of the

52. Detail showing iris, vine and peony, from *The Virgin and Child ('The Madonna with the Iris')*, 16th century, in the style of Albrecht Dürer.

53. Detail of yellow iris from *The Wilton Diptych: The White Hart*, about 1395–9.

the White Hart panel in *The Wilton Diptych* [3, 53] – and they appear in the later paintings, such as Monet's picture of the iris beds in his garden at Giverny [54]. The irises have adapted superbly to the demands of Impressionism. The view is dramatically angled down onto the beds; the plants mass and blur over the curve of the path. Individual details of petal and leaf, and their old symbolism, are replaced by the sensation of vigorous growth and the fall of light and shade on pale pointed leaves. And yet it is astonishing that that they remain unmistakably irises; the complex rise and fall of their silky petals is caught up in the conspiracy to create a quite different view of what is real.

54. Detail from *Irises*, about 1914–17, by Claude-Oscar Monet.

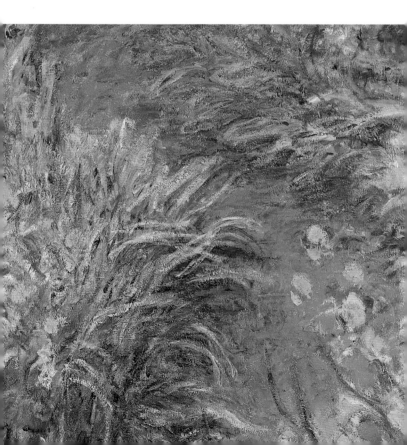

EXOTIC PLANTS, FRUITS AND GARDEN HYBRIDS

Tulips were not a traditional flower in European art. In the late sixteenth century they arrived, like a conquering army from the East, with all flags flying. They lacked edible value or religious significance but they did represent the bold spirit of an age when Turkish armies still bombarded the walls of Vienna; when the Dutch fought off foreign tyranny to create a prosperous new nation; and when sea trade and capitalism remoulded European society. Tulips were for gamblers.

The credit for introducing garden tulips from Constantinople to Vienna goes to Ogier de Busbecq, who in 1554 conducted an Austrian embassy to Suleiman the Magnificent. As he journeyed through Turkey he saw tulips growing wild in drifts of bright colour and also cultivated in the palace gardens. Busbecq would have found favour with modern conservationists, since the bulbs and seeds he brought back to Europe were of the cultivated varieties ('presents' he called them 'which cost not a little'), and they were already hybridised beyond recognition of their original wild species. Busbecq also introduced the name tulip – though this was based on a mistake or a joke, since the Turkish *tülbend* was the word for turban. The correct Asian name for the flower was *lale* – like our lily – and as the herbalist Johnson wrote in 1623: 'Truely I think these are the lilies of the field that Solomon in all his glory was not arrayed like one of these.'

By the time Bosschaert painted *Flowers in a Glass Vase* [55] in 1614, tulips were collectors' items. The plantsmen of Europe had discovered that the colours and patterns in their petals were more vivid and varied than any other flower; and although they did not realise this streaking or 'breaking' of colours was caused by a virus, they knew only too well that those wonderful blooms, and the bulbs that bore them, were ephemeral. This simply added to their rarity and their value. Holland, although not the only country involved in tulip development, led the field. (John Tradescant, gardener to Charles I and Henrietta Maria, went to Haarlem and brought back hundreds of

tulips for the royal gardens.) The Dutch pre-eminence was due initially to Clusius, the great botanist who moved from Vienna to become Professor of Botany at Leyden in 1593, and cultivated the early tulips there. The growing fashion was complemented by an existing tradition for depicting plants with botanical precision and quasi-spiritual admiration which Bosschaert and his contemporaries inherited. At the same time a thriving market for tulips and for flower paintings was provided by the new commercial wealth and the more worldly, swashbuckling attitudes that went with it. The average painting by Bosschaert might cost 300 guilders, but when speculation was at its height, any one of the tulips he painted might have fetched 3,000 guilders. In the event, the painting proved the better investment, since in 1637 tulipomania caused an early and typical crisis in the capitalist system; confidence was lost and the market collapsed. Flower painting however remained steady.

While the beauty, rarity and opulence of the flowers were celebrated as if they were jewels against their darkly painted backgrounds, it is possible that there were other layers of meaning in these pictures. They perhaps no longer represented such direct links with salvation or sin, but still contained the Biblical message that 'Man's days are as grass'. (Psalm 103: 15.) Bosschaert's fly – like watches, hourglasses and skulls in certain other flowerpieces – may be emphasising a message of transience and decay. The yellow tulip 'flamed' with red, of a type known as *bizarre*, has a caterpillar advancing hungrily up its stem; and while the tulip is 'bolt upright on its stalk like a goblet' (as Gerard said the finest tulips should be), beneath it droops the sinister, mauve, snakeshead fritillary, enlarged to twice its natural size to emphasise the contrast with the tulip. Balthasar van der Ast, who trained with Bosschaert, has used the same juxtaposition, and added a very sharp branch of blackthorn for good measure [56, 57].

Not only are the relative sizes of the flowers unnatural, so are their seasons, with the narcissus and rose especially unlikely to be in bloom together. The price of assembling such an arrangement would also have been prohibitive. For instance Bosschaert has chosen for his 'top flower' a rose tulip – white 'feathered' with red – highly prized markings characteristic of *Semper*

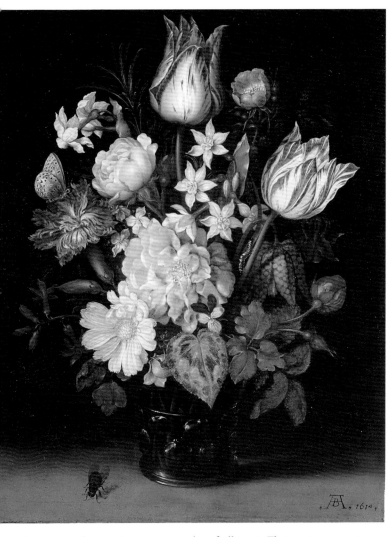

55. Ambrosius Bosschaert the Elder, *Flowers in a Glass Vase*, 1614, including tulips, narcissi, roses, carnation, wallflowers, hyacinth, marigold, cyclamen, heartsease, fritillary and columbine.

Augustus, the most expensive tulip of all time. These arrangements were not therefore intended to reproduce real bouquets but were artistic constructs from individual flower sketches held in the studio. As such, they provide a visual record of developments in horticulture that are still dew-drop fresh and very informative. Bosschaert's white and yellow narcissi may look familiar to us, but they were a startling new departure from the heavy-trumpeted, single-flowered daffodils native to Europe. Likewise the roses; Bosschaert has placed a wild dog rose between the tulips, but his large central damask rose – blushing as it opens and then turning pale – was recorded as a

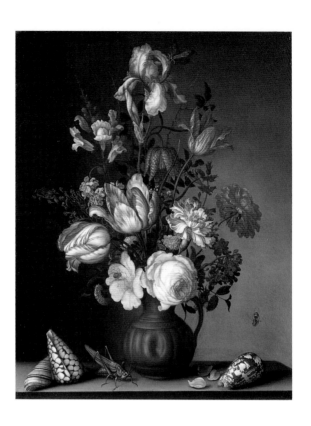

56. Balthasar van der Ast, *Flowers in a Vase with Shells and Insects*, about 1616.

57. Detail of 56 showing tulip, fritillary and blackthorn.

58. Detail of 56 showing Austrian briar rose, centifolia rose and lilac.

new introduction (from the East Mediterranean, if not Damascus itself). Balthasar van der Ast's pink centifolia rose was a new garden hybrid [58], sensational because the stamens disappear in a mass of tightly folded petals; and Ast's single yellow rose, which is being admired by a spider, was another oriental plant (like tulips), first nurtured by Clusius while he was in Vienna, and still known as the Austrian briar rose, despite its Persian origins. The lilac in the background of Ast's flowerpiece arrived in European gardens by the same route, and was much praised when it graced their fountain courts and formal avenues; but the history of plants is often complicated and the wild ancestors of lilacs were finally tracked down in the Balkans. Meanwhile the iris had undergone a transformation – its blue-white petals were 'feathered' sky-blue to rival the red streaks of the tulips and carnations. However there was generally room in the seventeenth-century vases for a few flowers that were traditional even then, such as heartsease and columbine, wallflowers, snapdragons and marigolds.

46

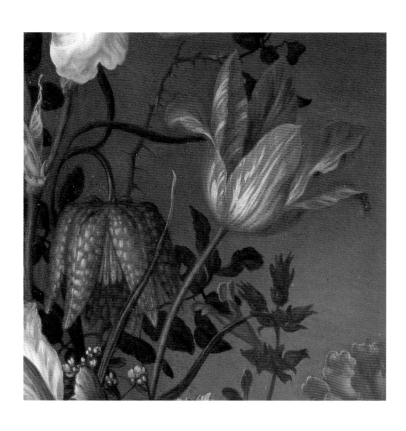

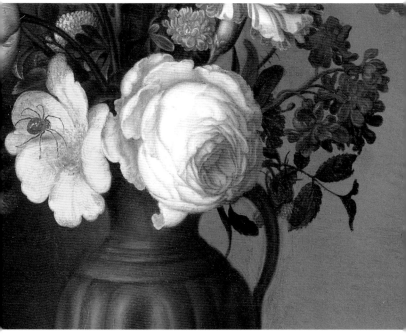

59. Rachel Ruysch, *Flowers in a Vase*, about 1685.

60. Jacob van Walscappelle, *Flowers in a Glass Vase*, about 1670.

61. Detail of 60 including tagetes, tulip, Byzantine gladiolus, wheat, yellow lily, Turk's cap lily and morning glory.

62. Detail of 59 showing honeysuckle and auricula.

By the second half of the seventeenth century, when Jacob van Walscappelle [60, 61] and Rachel Ruysch [59, 62] were active, there was a change of texture in the flowers – as if jewels had given place to silk scarves – and a growing emphasis on opulent doubleness. For pride of place roses were sometimes dislodged from their central position by peonies or opium poppies, which had been familiar and medicinal in the Middle Ages, but only in their single form and with little colour variation. The archetypal white lily of sacred art was replaced with yellows and oranges, the recurved petals of the Turk's cap lily, or the purple trumpets of the Byzantine gladiolus. From across the Atlantic, flowers first noticed by those who accompanied Columbus, or the *conquistadors,* were adding a vibrant note – orange tagetes to outdo their European relatives the marigolds, and deep blue morning glories, far more appealing to the artist's eye and better behaved in the garden than our wild convolvulus. And yet both Walscappelle and Ruysch paid homage to the hedgerow – between them they included honeysuckle, hawthorn, guelder rose (admittedly a garden cultivar called snowball), blackberries, wild strawberries and ears of wheat. These gave contrast to their exotics, and a sense of sinuous life and movement which would otherwise be lacking. Ruysch has even made columbines her 'top flower'.

49

But, when it came to the Rococo interiors of the eighteenth century, masses of double flowers, curving stems, large leaves and loose petals were deemed necessary to provide a suitably operatic accompani-

ment; and the two National Gallery paintings by Jan van Huysum demonstrate how he led the transformation in flowerpieces. In the first, painted early in his career, the flowers are still individually exquisite against their sombre background [63]; but in the second, dated 1736, there is an explosion of petals; the viewer looks upward at a cascade of colour, and the niche behind is lit by the flare of light [64]. There is more novelty in the style than in the flowers, but the emphasis on doubleness has become overwhelming. The peonies and poppies still did it best, but others had more rarity value. The yellow rose, for instance, proved very hard to develop in the climate of Northern Europe because the Austrian briar rose took centuries to hybridise, and the double sulphur rose refused to open its buds if it got wet. It was one of the flowers Jan van Huysum found hardest to obtain and, hanging over the side of the terracotta vase, it seems to gloat from its favoured position at the pink centifolias lying below, and then leads the eye upwards to another treasure – the double yellow hollyhock [65, 66].

50

64. Jan van Huysum, *Flowers in a Terracotta Vase*, 1736.

65. Detail of 64, including double opium poppies, double yellow hollyhocks and striped tulips.

The hollyhock was one of the oriental flowers that arrived long before the tulip invasion, reaching Europe via the Moorish gardens of Spain, but retaining a hint of foreignness in the French name *rose d'outremer* or *rose tremaire*. Double hollyhocks were developed during the seventeenth century – a pale double yellow being first raised by the Duke of

Orleans – at which time, 'being so great and stately', they were considered fittest for palaces with spacious gardens. Another flower that had achieved double-ness, and with it pre-eminence, was the hyacinth. Although it earned a place in Bosschaert's glass vase, it was cast in the shade, as a humble though fragrant travelling companion of the tulip. But the double hyacinths in van Huysum's collection – diagonally opposite the tulip – would have rivalled it in a nursery-man's catalogue both for rarity and for price.

66. Detail of 64, including auriculas, double yellow sulphur roses, double peony and double tagetes.

Another newcomer to flowerpieces, and to the ranks of florists' flowers, was the auricula which, being comparatively tiny, clustered around the lip of the vase or lay at its base. Auriculas too were intro-duced by Clusius, but from the Alps, not from the East. In the wild they are a soft yellow, like primroses, and at first they shared the same reluctance to exchange their natural habitat for the demands of cultivation. During the seventeenth century, as can be seen in Ruysch's flowerpiece [62], they had been coaxed into sunset colours. Then the paste – the con-trasting centre evident in van Huysum's auriculas – was developed to highlight the velvety shades and stripes on the outer petal. The most valued colours were listed thus: 'black, willow, mouse, greenish-hair and light-tawny'.

Paulus Theodorus van Brussel, who carried the standard of van Huysum through the second half of the century, used the same fashionable flowers and, if possible, they were even more full-blown [67]. His tulips were not double but their magnificent petals spread out even wider than a peony, while the iris that van Brussel (and van Huysum) favoured was *Iris xiphioides* [68] which bears two or three flowers within

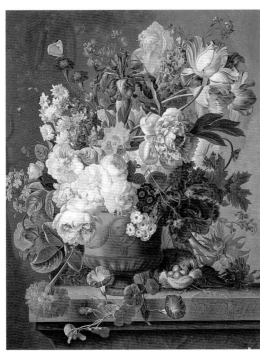

67. Paulus Theodorus van Brussel, *Flowers in a Vase*, 1789.

68. Detail of 67 including double hyacinths and *Iris xiphioides*.

one calyx and provides a vibrant blue. It was brought to Bristol from Spain in the sixteenth century (before religious differences embittered relations), and from there, under the false name English bulbous iris, it was sold on to the Dutch bulb-merchants.

69. Detail of 67 showing (on the ledge) tagetes, morning glory, nasturtium, sunflower and aster; (in the vase) centifolia rose and auricula.

Echoing the same brilliant blue as the iris, morning glory became almost the *sine qua non* of a flower-piece, most effective when twining round the base of a terracotta urn [69] – and here beautifully entwined with a nasturtium (another introduction from Central America), which was first welcomed as a new kind of cress and added to salads. Indeed van Brussel's display of flowers from the New World is not only visually arresting, but suggests that the old search for hidden meanings could still be intended. Falling out of the vase on either side are American flowers – tagetes, aster and sunflower. The American War of Independence had recently galvanised the politicians and intellectuals of Europe and suggested revolution to the French. In 1789, the date of the painting, General Washington was elected first President of the United States. The flowers may echo the dramatic power-struggles and changes of the period.

Sunflowers had always been symbols of power because of their astonishing height, and the determination of the vast flowers to face the sun which they seem to reflect. Long before they reached Europe, the Incas had made sunflowers emblems of their sun god. Sunflower seeds were among the first to be brought back across the Atlantic, and the plants were described in 1569 by the Spanish botanist Monardes

in the first Flora of America, which was translated into English under the title *Joyfull Newes Out of the Newe Founde Worlde*. When Van Dyck painted his self portrait facing a sunflower [70] he was celebrating his appointment as court artist to Charles I; and the chain around his neck supports the King's medallion which he is holding in such a position to face the sunflower. Charles I knew all about the habits of sunflowers, and their smaller relatives, when he wrote these lines in prison in Carisbrooke Castle:

> *The marigold observes the sun*
> *More than my subjects me have done.*

Like royalty, sunflowers were not always in favour. It was pointed out that they incommode other flowers, and they came to be valued chiefly as oil-seed crops until Oscar Wilde and Van Gogh, in their very different ways, gave them renewed aesthetic status.

Van Gogh himself seems to have known that his series of sunflower paintings would be his most famous subject [71] – 'the sunflower is mine in a way'. So did Gauguin, who painted him trance-like, facing a vase of sunflowers with arm and brush extended towards the canvas as if an electric charge were passing through him. In certain letters Van Gogh's own words also captured the force that he felt and transmitted

70. Sir Anthony van Dyck, *Self Portrait with a Sunflower*, 1633. Collection of the Duke of Westminster.

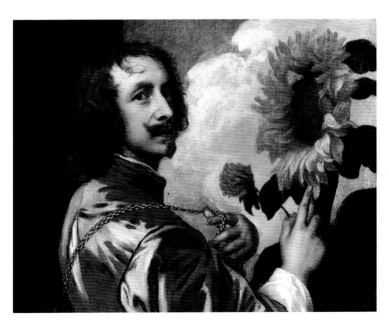

back into the painting: 'draw quickly, very quickly,
like a lightning flash.' (Letter 500, June 1888.) 'The
raw or broken chrome yellows will blaze forth on var-
ious backgrounds from the palest malachite to royal
blue.' (Letter B15, August 1888.) 'Now to get up
enough heat to melt the gold, it needs the whole and
entire force and concentration.' (Letter 573, January
1889.) And profounder still (he was actually describ-
ing his painting of a reaper in a field of wheat, but it
could apply to all flower paintings, and most espe-
cially his own): 'It is an image of death, as the great
book of nature speaks of it. But there's nothing sad
in this death, it goes its way in broad daylight with the
sun flooding everything in a pure gold light.' (Letter
604, September 1889.)

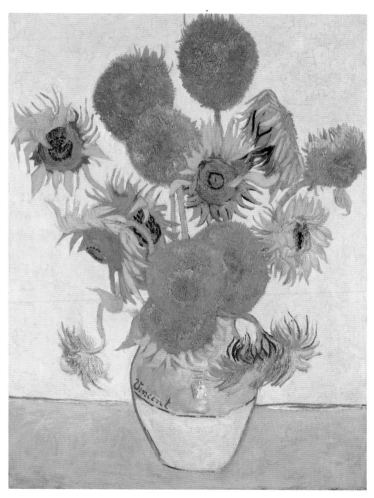

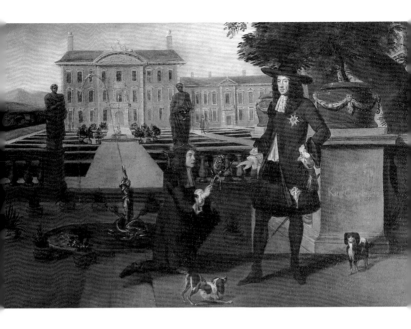

There is serendipity in the fact that the National Gallery can boast an unusually large total of four paintings with pineapples, since it practically marks the spot where the first pineapple was raised in England – an event so momentous that a painting commemorates it [72]. Standing on the terrace of a formal garden, Charles II stretches out his hand to receive a pineapple which is being offered to him by John Rose, Superintendant of the Royal Gardens at St James's Park – an eminent plantsman with his own commercial nursery at St Martin-in-the-Fields. He was famed for his skill at rearing fruit trees and several pots, including at least two young pineapple plants, are displayed on the terrace as proof. The date, and even the event, have been disputed, although the scene would hardly be authentic or logical unless Rose had himself reared the pineapple. In 1661 John Evelyn recorded that, four years earlier, the first pineapple in England, 'the famous Queen pine', was brought from Barbados and presented to His Majesty – a statement that would only make sense (since Charles II was not restored to the throne until 1660) if the actual pineapple fruit took some years to materialise. Evelyn recorded the production of another royal pineapple in 1668 when it was the centrepiece of a banquet for Louis XIV's ambassador, Colbert.

72. After Hendrik Danckerts, *Charles II receiving a Pineapple*, seventeenth century. London, Ham House.

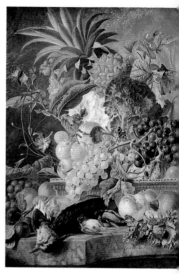

73. Paulus Theodorus van Brussel, *Fruit and Flowers*, 1789.The fruits include pineapple, white-currants, plums, blackberries, grapes, apples, gooseberries, medlars, melons, peaches and cherries.

74. Wybrand Hendriks, *Fruit, Flowers and Dead Birds*, about 1780. The fruits include pineapple, rosehips, grapes, plums, damsons, peaches, pomegranates and walnuts.

It was also recorded in 1657, in Captain Ligon's *Exact History of the Island of Barbados*, that the fruits themselves rotted before they were half-way across the Atlantic; so it must have been the plants that endured the prolonged sea crossing, and John Rose who was responsible for coaxing them to grow and set fruit. Meanwhile in Leyden similar successes were being achieved by Pieter de la Cour, and after Rose died in 1677 it was the Dutch who established pre-eminence in the field of pineapple rearing – and later painting – to such an extent that subsequently it was claimed that the first pineapples arrived in England with William and Mary in 1690; or even with a Dutch resident of Richmond called Matthew Decker who, in 1714, earned acclaim for his pineapples, and amazement at the huge numbers of plants he grew in order to produce a few fruit. The skill and expense involved in their cultivation ensured that pineapples remained a status symbol until the days of canning, refrigeration and fast Atlantic crossings. In *Northanger Abbey*, Jane Austen poked fun at General Tilney's pride and anxiety over pineapple production ('the pinery had yielded only one hundred in the last year'), and a fashion craze developed for pineapple finials and other decorative items which came to symbolise hospitality on a grand scale.

The succession beds in which pineapples were produced under glass were created from tons of horse manure, straw and bark skilfully mixed to raise the temperature as they fermented and rotted. This was a refinement of methods used by the Romans to raise out-of-season melons and cucumbers, and possibly the technique was never quite lost in certain monastic institutions which had time and tradition on their side. But in the sixteenth century, alongside the many introductions and improvements in horticulture, pumpkins, gourds and melons started to grow huger and sweeter. In France and Holland the golden-fleshed honeydew type of melon was produced; Catherine de' Medici gave herself indigestion with them as she dreamt of massacring Huguenots; and the Tudor monarchs, not to be outdone, set up melon yards and keepers of the melons. Like virtually all exotic

75. Detail showing pineapple and medlars from *Fruit and Flowers in a Terracotta Vase*, 1777–8, by Jan van Os.

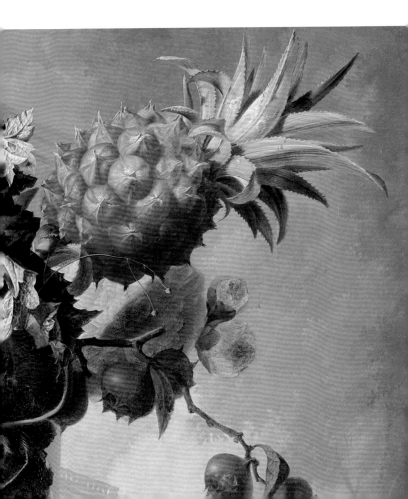

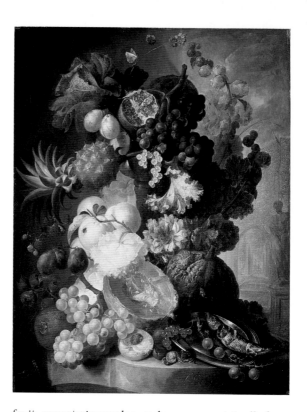

76. Jan van Os,
Fruit, Flowers and a Fish, 1772.

77. Detail of 76 showing white nectarine, grapes, melon, peach, redcurrants and nuts.

fruit, except pineapples, melons came originally from Asia and had long been known in the Mediterranean world – what was new was their succulence and variety. In earlier paintings not even pomegranates had burst open to display their seeds and flesh as temptingly [title page]; nor had any peach yielded place to a whole branch of white nectarines; no plums (which had probably been almost as sour as sloes) appeared as the very latest golden and purple cultivars; and medlars were generally considered far too rude to appear at all – their common name in most languages being a variation on 'dog's arse' – because of the curious enlargement of the flower scar at the base of the fruit. Contentedly eating nuts at the base of van Os's feast for the eyes is a tiny mouse [77], the one hint of ambivalence in the painting. Even our animal-loving age would not relish such liberties; and at the very least the mouse serves as a reminder that the goodness of fruit is of very short duration.

Redcurrants and gooseberries had been around for as long as anyone could remember, and the French had never bothered to distinguish between

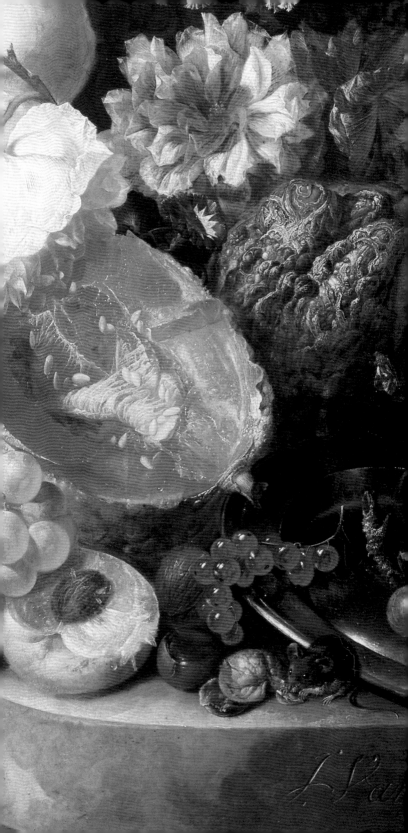

78. Detail from *Still Life with Drinking Vessels*, 1649, by Pieter Claesz.

them since the same old Frankish word – *groseille* – served for both. But the *Diary of Parson Woodforde*, who wrote about his parish in Norfolk, indicates that in the 1760s in England redcurrants and the newly fashionable whitecurrants were popular, and he ate quantities of gooseberries either in tarts or with oily fish – the latter way of serving being also suggested in van Os's painting. (On the other hand Parson Woodforde treated blackcurrants as good only for a medicinal sort of jam, and van Os also excluded them from his chosen fruits.)

There is another fruit van Os has not included, which in earlier still lifes was the very apogee of sweet opulence – strawberries, often shown heaped in a Chinese Ming bowl [78]. This type of bowl was named after the dynasty which ruled China when sea trade first opened with the West, enabling the Dutch to import the precious blue and white porcelain which inspired their own Delft pottery. Like redcurrants and cherries, the strawberries themselves were nothing new – all three appeared in scenes of the Virgin and Child, or saints, and may have symbolised the sweet purity of the Virgin, or drops of Christ's redeeming blood. Conversely, when Bosch painted his *The Garden of Earthly Delights* soon after 1500, he used

various fruits, including a gigantic strawberry, for the scenario in which his ridiculous but seductive people took their pleasure [79]. The Garden panel is flanked on either side by scenes of the Fall of Man and Hell, and Bosch was not condoning these activities, however fascinating the details. His fruits may have had a far more obvious sexual message for those of his contemporaries who were familiar with bawdy songs and proverbs. According to Siguenza, a Spanish priest who admired *The Garden of Earthly Delights* in 1605, it was then called *The Strawberry Plant*, and to him it spoke of 'The vanity and glory and transient taste of strawberries, the fragrance of which one can hardly smell before it passes'. This comment may be nearer in mood, as indeed it was in time, to an early still life of strawberries; although no words can quite complement, as satisfyingly as the delicate blue and white porcelain of a Ming bowl does, the beauty and fragility of the fruit.

To any eye that has just lingered with delight and curiosity over van Os's heaped fruit, or Pieter Claesz.'s spilling strawberries – marvelling at the deft touches of light and colour and the richness of detail and form –

79. Detail from *The Garden of Earthly Delights*, about 1504, by Hieronymus Bosch. Madrid, Museo del Prado.

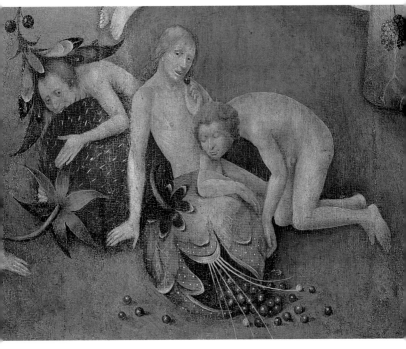

80. Paul Cézanne, *Still Life with Apples and Melons*, about 1890–4.

turning to Cézanne's study of melons and apples [80] can still shock (as his work originally did) with something completely new. It seems crude. The grey background is visibly scraped on over the canvas and haphazardly blobbed with mauve and brown. The composition tilts forward in a way an old master would have taken care to avoid, and the fruit does not convey its message straight to the taste buds. Besides, the plate and the ginger jar are not properly rounded. No one has ever found Cézanne's paintings more difficult than he did, and he struggled with them long after the fruit would have rotted. But suddenly that challenge can transform everything. As one puzzles over the shades of orange the flesh of the melons grows succulent; the different greens and textures of their skins become a deeply satisfying contrast; the apples come to life in other tones of the same colour. Then the grey background and brown table seem to be a wonderful foil – the white folds of the cloth and the hardness of the china rendering the fruit softer and juicier. The limits of illusion have been surpassed; these become fruits of the mind and the satisfaction they give is the more profound.

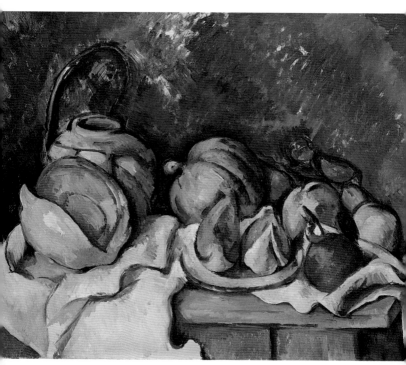

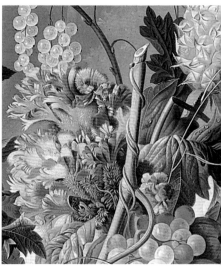

The adaptations, variations and long-distance travel of which plants are capable, especially when helped on their way by humans, become increasingly apparent as the paintings advance through the centuries. One of the first flowers – as distinct from fruits – to benefit from hothouse cultivation was the celosia, also known as cockscomb or floramor, which had arrived from tropical Asia in time to be praised by John Gerard in 1598: 'It farre exceedeth my skill to describe the beautie and excellence of this rare plant called Floramor; and I think the pensil of the most curious painter will be at a stay when he shall come to set it down in the lively colours … that Nature hath bestowed in her greatest jolitie upon this floure.' There was indeed a gap of almost two centuries before Hendriks and van Brussel rose to Gerard's challenge and included celosias – exotic and obviously pampered – alongside their pineapples [81, 82]. And it took another hundred years to produce Gerard's 'most curious painter' ever to express 'Nature's jolitie', since that description most aptly fits Henri Rousseau.

Rousseau created his tropical jungles, which are varied and atmospheric beyond the bounds of realism, by combining a thwarted desire to travel with visits to the Jardin des Plantes in Paris. In the hothouses he studied the lush and leathery leaves and transformed them into steamy landscapes [83]. His tiger leaps through sword-like agaves (*Sansevieria trifasciata*)

81. Detail from *Fruit, Flowers and Dead Birds*, about 1780, by Wybrand Hendriks, showing red celosia with grapes and pineapple.

82. Detail from *Fruit and Flowers*, 1789, by Paulus Theodorus van Brussel, showing pink celosia with whitecurrants, grapes and pineapple.

from Africa, towards the dark leaves of a young rubber plant (*Ficus elastica*) from India. Immediately beneath the tiger are the long, tapering stems of a euphorbia (*Pedilanthus tithymaloides*) from America, and behind it a fan palm (*Sabal palmetto*), also from America. The tiger's tail curves past a clump of pampas grass (*Cortaderia selloana)*, while the red conifer tree on the right is an American swamp cypress (*Taxodium distichum*), which turns colour before shedding its leaves. The ghostly grey tree-trunks in the distance are probably eucalyptus trees from Australia; while above the tiger's back is the peepul or bo tree of India (*Ficus religiosa*); and, spreading all across the sky, the weeping Java fig (*Ficus benjamina*), whose drooping branches eventually root themselves to form new trunks. The tree on the left above the pampass grass is golden rain (*Koelreuteria paniculata*), which has become a popular street tree in France – sometimes called Pride of India (although it originates from China).

The sense of wonder and enchantment evoked by Rousseau's painting in no way depends on such

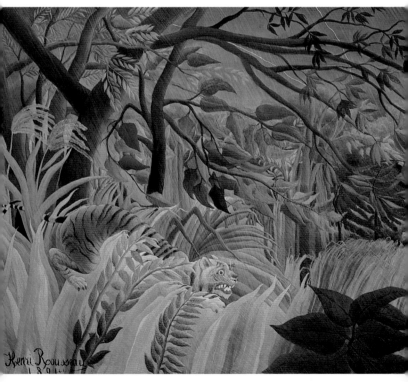

84. Paul Gauguin,
A Vase of Flowers,
1896.

botanical knowledge, but it does echo his own amazement and curiosity at the plant wealth gathered from all over the world by his more pioneering countrymen. Meanwhile Paul Gauguin underwent a reverse process and travelled to the Pacific to enrich the Symbolist vision behind his art. He thus placed the flowers of Tahiti in a dark vase of local pottery, with no wish that they should be identified, but in order to convey colour, form and his own imaginings [84].

Although Henri Fantin-Latour's vase of flowers entitled *The Rosy Wealth of June* was painted only a few years before the tropical fantasies of Rousseau and Gauguin, it belongs to another world of nineteenth-century drawing rooms and cultured conversation [85]. And yet in terms of the flowers themselves, it is not as traditional as it seems; these were the very latest, highly fashionable blooms. The rose may be the most ubiquitous of flowers, done almost to death by artists and poets, but Fantin-Latour's roses [86] represent a new race which culminated in the Hybrid Tea rose, first bred in 1867 by the French nurseryman Guillot of Lyons. The nineteenth-century explosion of rose breeding had its inaugural celebration in Joseph Redouté's three-volume record of the Empress Josephine's collection at Malmaison. The vital factor had been the introduction of the China rose around 1750. Although its loose silky blooms had little to contribute in terms of shape or colour, it was capable of flowering repeatedly throughout the summer and

85. Ignace-Henri-
Théodore Fantin-
Latour, *The Rosy
Wealth of June*,
1886.

86. Detail of 85,
showing roses.

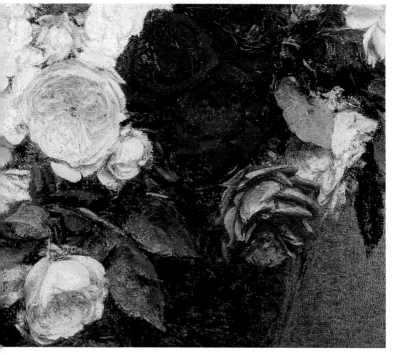

autumn, whereas the old roses had always been
bywords for brevity. Thus the crossing of the China
rose with the sturdier and more colourful roses of
Europe first created the Bourbon rose (Fantin-Latour's
have petals the colour and texture of whipped cream);
then the Hybrid Perpetuals (the first was the *Rose du
Roi*, named in 1816, gloriously scented and double,
which may well be the deep crimson rose depicted by
Fantin-Latour); and finally the Hybrid Tea roses,
whose most recognisable feature was the recurved

68

87. Detail of 86 showing dahlias, gladioli, delphinium and hydrangea.

88. Detail of 86 showing begonias.

edges of their petals (like Fantin-Latour's pink roses) and an exotic smell of fresh tea leaves, derived from a fragile antecedent, the Tea rose.

One other flower in Fantin-Latour's vase owes its presence to the gradual and reluctant opening of China to the West – the pink begonias on the left [88] are *Begonia evansiana*, a tall but dainty representative of the breed which still retains its original form (most other begonias originate from Central America, but our knowledge of them has been overwhelmed by a dazzling mass of cultivated forms). Also from the East, but from the colder regions of Siberia, are the delphiniums, painted by Fantin-Latour at just the moment when they had started their development as modern border plants. They were produced by crossing several species, but especially *Delphinium elatum* and *Delphinium grandiflorum*. In 1881 the English specialist nursery of James Kelway had listed sixteen different delphiniums; in 1889 there were one hundred and thirty seven. Crowded around the delphiniums

(on the right), Fantin-Latour has placed pink and white gladioli [87], whose name is derived in traditional style from the Latin for sword, because of the shape of the leaves. Indeed the Byzantine gladiolus, which is a regal magenta, had long been known in Europe; but these are the gladioli of the Cape and Southern Africa, which had been arriving into the hands of European and American hybridisers for about a hundred years, but still retained their delicate form and colour. (The twentieth-century vulgarisation followed subsequent discovery, near the Victoria Falls, of yellow and orange gladioli.)

Fantin-Latour's begonias and gladioli may have been reared in a greenhouse to ensure their presence in a June bouquet; and the red and yellow dahlias must indeed have received hothouse treatment to flower before the full baking of a long hot summer. Dahlias originate from Mexico, where the Aztecs had loved and hybridised them for centuries before the Spanish conquest. But they did not adapt easily to Europe. Some seeds arrived in Madrid in 1789; and as a result of Napoleon's conquests, Josephine subsequently received a few precious tubers which she is said to have planted at Malmaison with her own hands. Only after peace was made did some of the French dahlias reach England, and from the 1830s onwards Europe enjoyed a craze for them. Beneath the dahlias, in the centre of the painting, is a white hydrangea, *Hydrangea arborescens*, from North East

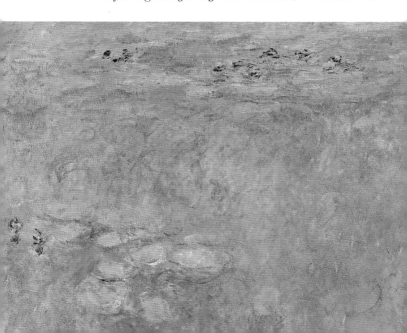

America. In the 1880s the recent arrival of blue and pink hydrangeas from China, lacecaps from Japan, and this large variety of the American hydrangea found in the mountains of Pennsylvania in 1860, had resulted in a surge of interest involving watering with chemicals to turn pink into blue and competion to produce the largest flower-heads – further proof that this bouquet was the *dernier cri* in all things floral.

Monet's water lilies [89] can also be seen from this perspective, for they too had just been created through the fanatical determination of a French plantsman. Bory Latour-Marliac had devoted his entire garden at Temple sur Lot to pioneering a method of hybridising wild water lilies to provide Europe with a plant more akin to a lotus. After fifteen years of fruitless effort he was able to produce, name and market *Nymphaea marliacea* – shades of pink in 1879 and the yellows in 1880. Meanwhile, from the start of his long career, Monet had been fascinated by juxtaposing the compact brilliance of flowers with the eddying reflections of water. Once Monet had created his water garden at Giverny, and Latour-Marliac had created ornamental water lilies, an apotheosis was possible. Monet's *paysages d'eau,* like Rousseau's jungles, are landscapes where the artist's eye has dreamed for hours, achieving wondrous transformations. But the delight with which we enter into the paintings would be less if we did not sense that the artist sought his inspiration from real plants.

SYMBOLISM AND REALISM

If one studies the history and symbolism of plants in paintings, one has to question each time if the plants were chosen by the artist for their visual qualities, or for the meaning they conveyed. The plants that appear in portraits sum up this dilemma. Are they simply to be held or worn by the sitter, or to decorate the surroundings; or are they clues to identity and sentiment? For example, pinks and carnations were once widely recognised as tokens of betrothal; but they cannot by themselves be taken as proof that a portrait celebrated such a turning point in the sitter's life [91]. Their sweet smell also made them a natural flower for nosegays; nor were such nosegays purely ornamental, since they served to counteract foul odours and even the threat of infection from disease and pestilence. Wallflowers and stocks were similarly used in posies and (since flowers were grouped with those they most resembled), they too were originally named gillyflowers for the hint of cloves in their scent; or violas for their likeness in fragrance to violets. Meanwhile the Latin name for wallflowers,

90. Detail of posy with wallflowers and pinks from *Costanza Caetani*, probably about 1480–90, attributed to Fra Bartolommeo.

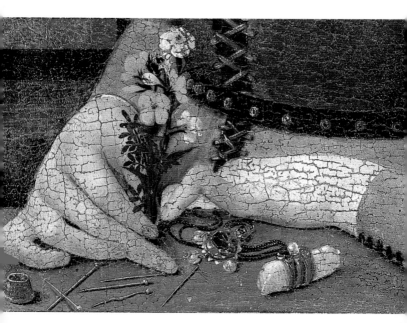

Cheiranthus cheiri, confirmed that they were used as flowers for holding in the hand, to give comfort. Wallflowers in a portrait might also suggest a broken heart, since they were poetically linked with the story of an imprisoned maiden who cast a wallflower from the battlements of her castle tower to a minstrel singing below – but on attempting to join him she fell and died. From that time wallflowers became the badge of minstrels who wished to hint, in the tradition of courtly love, at a lost or unattainable love; but more generally wallflowers came to indicate faithfulness. Forget-me-nots were also flowers of romance and fidelity with mournful overtones. In *The Wilton Diptych* they are among the plants that commemorate Richard II's Queen [3]. Held gently in the hands of the lady about whom little is known – except that she belonged to the Hofer family – the forget-me-nots again suggest loss and remembrance [92]. The German name *vergisz mein nicht* was certainly in use in her

91. Andrea Solario, *A Man with a Pink*, about 1495.

GEBORNE HOFERIN.

92. Swabian, *Portrait of a Woman of the Hofer Family*, about 1470. She is holding forget-me-nots.

time and predates the English equivalent, while the fly on her impressive white headdress is possibly another symbol of mortality.

If the flowers whose traditional meanings are widely known can raise more questions than they answer, an unusual plant is all the more intriguing. Holbein's portrait of a *Lady with a Squirrel and a Starling* [93] is mysterious in many ways. It is probable that she was English, painted during Holbein's first visit to England in 1526 to 1528, during which he also painted the family of Sir Thomas More. Why she chose to be accompanied by a squirrel and a starling remains unexplained. Are they part of a lost proverb, an anagram or an emblem, and should the plant behind them be included in the puzzle? It resembles a plant motif used in the backgrounds of other paintings by Holbein and, being more decorative than botanically accurate, may not be intended to convey any particular meaning. The leaves are like

74

a vine, but the wooden branches are not. Between certain stems fruits seem to be developing which look most like young figs; but figs do not have tendrils. It could possibly be a hop plant, which does have such tendrils and woody stems, and Holbein's somewhat stylised leaves could as well be hops as vines or figs. It may even be significant that hops were newly introduced to cultivation in England, the first Kentish hop garden having been established in 1520. (Although long-favoured as an ingredient of beer in Germany and the Netherlands, attempts to introduce hops to England in the fifteenth century had been treated with suspicion. They were blamed for fuelling Jack Cade's rebellion in 1450, and several town edicts had banned their use.) It would be delightful to discover that this sober-looking lady belonged to a family with controversial brewing interests, but evidence based on a plant that is hard to identify is not admissible. If Holbein had given the plant mature fruit – whether

93. Hans Holbein the Younger, *Lady with a Squirrel and a Starling,* about 1526–8.

75

94. Alesso
Baldovinetti,
*Portrait of a Lady
in Yellow,*
probably 1465.

grapes, figs or hops – the doubt would be dispelled. But perhaps the fruits were deliberately omitted.

There are two portraits in the National Gallery which contain plants extremely relevant to the sitter's identity, and both are palms. Alesso Baldovinetti's *Portrait of a Lady in Yellow* [94] is striking both for her determined profile and her huge sleeve decorated with a fan palm (*Chamaerops humilis*). It was the palm which enabled her to be identified as Francesca degli Stati, wife of Angelo Galli, a courtier and diplomat of Urbino (whose feathers also appear on her sleeve). In 1445 Francesca became the great heroine of Urbino when she foiled a plot to assassinate Duke Federigo da Montefeltro. Praises, sonnets and mementos of the Contessa delle Palme circulated around the ducal palaces, and one marquetry door still bears her triple

palm. Naturally the whisper survived that 'a certain Contessa Palma of Urbino was said to have been the Duke's mistress'.

Van Dyck's portrait of *William Feilding, 1st Earl of Denbigh* [95], with a coconut palm, was done to celebrate the earl's return in 1633 from a curious visit to India. Two years earlier Charles I had appointed him ambassador to Persia – although there is no record that he visited that country – and supplied him with open letters to the Moghul princes of India explaining that Feilding was 'transported with the fame and glory of the Moghul empire'. Meanwhile the East India Company was so suspicious of his motives that they refused him a horse, and later accused him of smuggling home bales of cloth and many jewels. Feilding

95. Anthony van Dyck, *William Feilding, 1st Earl of Denbigh*, about 1633–4.

96. Detail from
43, *The Virgin and
Child with Saint
Anne*, 1510–18
by Gerolamo
dai Libri.

himself wrote rather ambiguously to his son: 'These doings I have thought better to undertake than to live at home, get nothing and spend all.' There seems initially to be a hint of disgrace in this desire for adventure, but Van Dyck's portrait records the nostalgic pride of safe return. Like a prophesy of future empire, the portly English figure appears to be on a hunting expedition, exotically dressed in red-striped silk *payjama*, and attended by an Indian boy who is pointing towards a parrot. Feilding appears pleasurably astonished – his descendants maintained this reflected his feelings for India – and the English landscape in which he belongs is transformed by a coconut palm.

Signs and symbols, clues and conundrums – plants can provide all these. The interpretation of their meanings is seldom as straightforward as their appeal, and there may be cases of mistaken identity, even on the part of artists. For instance, since the Italian word *cedro* could mean either citrons or cedar trees, it is possible that the widespread association of lemons with the Virgin and Child [43, 96] derived originally from Biblical sources and commentaries referring to the cedars of Lebanon. Lemons, however, proved a far more adaptable symbol, ranging from the chastity of the Virgin to the bitter sorrow of the Crucifixion, and even hinting sometimes at the fruits in the Garden of Eden or the golden apples in Greek myths. But, behind all the associations of which artists and viewers are capable, it is important to remember that the purpose of a plant is simply to exist. Our response to that message – however sub-conscious – is probably the most powerful of all.

PLANT LIST

Anemones/flowers of
Adonis
 Adonis annua

African or French
marigold
 Tagetes patula

Apple
 Malus sylvestris /
 Malus pumila /Malus
 domestica

Aster
 Aster novi-belgii

Auricula
 Primula auricula

Begonia
 Begonia evansiana

Bellflower
 Campanula sp.

Bindweed
 Convolvulus arvensis

Blackberry
 Rubus fruticosus

Blackthorn
 Prunus spinosa

Bracken
 Pteris aquilina

Byzantine gladiolus
 Gladiolus byzantinus

Campion
 Silene dioica

Carnation
 Dianthus caryophyllus

Cherry
 Prunus avium

Cinquefoil
 Potentilla reptans

Cockscomb
 Celosia argentea

Columbine
 Aquilegia vulgaris

Cucumber
 Cucumis sativus

Current (red, white)
 Ribes rubrum

Daffodil
 Narcissus sp.

Dahlia
 Dahlia coccinea

Daisy
 Bellis perennis

Dandelion
 Taraxacum officinale

Dead-nettle
 Lamium album

Delphinium
 Delphinium elatum/
 D. grandiflorum

Eryngium
 Eryngium sp.

Fern
 Dryopteris

Fig
 Ficus carica

Forget-me-not
 Myosotis sylvatica

Gladiolus/Sword lily
 Gladiolus sp.

Grape
 Vitis vinifera

Guelder rose
 Viburnum opulus

Hawthorn
 Crataegus monogyna

Heartsease
 Viola tricolor

Hollyhock
 Althaea rosea

Honeysuckle
 Lonicera periclymenum

Hyacinth
 Hyacinthus orientalis

Hydrangea
 Hydrangea arborescens

Iris
 Iris germanica, I. pseu-
 dacorus, I. xiphioides

Jasmine
 Jasminum officinale

Lemon
 Citrus limon

Lilac
 Syringa vulgaris

Lily
 Lilium candidum,
 L. bulbiferum,
 L. martagon

Lily of the valley
 Convallaria majalis

Maidenhair fern
 Asplenium

Mallow
 Malva sylvestris

Marigold
 Calendula officinalis

Mayweed
 Anthemis cotula or
 Chamomilla recutita

Medlar
 Mespilus germanica

Melon
 Cucumis melo

Morning glory
 Ipomoea tricolor

Mullein
 Verbascum thapsus

Narcissus
 Narcissus sp.

Nasturtium
 Tropaeolum majus

Opium poppy
 Papaver somniferum

Orange
 Citrus aurantium,
 C. sinensis

Palm (Coconut)
 Cocos nucifera

Palm (Fan)
 Chamaerops humilis

Peach (and Nectarine)
 Prunus persica

Pear
 Pyrus communis

Peony
 Paeonia officinalis

Pineapple
 Ananas comosus

Pink
 Dianthus plumarius

Pistachio
 Pistacia vera

Plantain
 Plantago major and
 P. lanceolata

Plum
 Prunus domestica

Pomegranate
 Punica granatum

Poppy
 Papaver rhoeas

Quince
 Cydonia oblonga

Rose
 Rosa alba, R. canina.
 R. centifolia,
 R. chinensis,
 R. damascena,
 R. foetida, R. gallica,
 R. haemispherica,
 R. muscosa

Rosemary
 Rosmarinus officinalis

Snakeshead fritillary
 Fritillaria meleagris

Snapdragon
 Antirrhinum majus

Speedwell
 Veronica chamaedrys

Stocks
 Matthiola incana

Strawberry
 Fragaria vesca

Sunflower
 Helianthus annuus

Tagetes (French and
African marigolds)
 Tagetes patula and
 T. erecta

Thistle
 Cirsium sp.

Tulip
 Tulipa sp.

Violet
 Viola canina

Wallflower
 Cheiranthus cheiri

Wheat
 Triticum aestivum

Water lily
 Nymphaea marliacea

FURTHER READING

G. Bazin, *Les Fleurs vues par les Peintres*, Paris, 1984.

W. Blunt and W. T. Stearn, *The Art of Botanical Illustration*, London, 1950; new edition 1994.

V. W. van Bonger and J. van Gogh-Bonger, *The complete Letters of Vincent van Gogh*, London and New York, 1958

J. Bumpus, *Van Gogh's Flowers*, London, 1989.

A. Coates, *Flowers and their Histories*, London, 1956; repr. 1968.

A. Coates, *Garden Shrubs and their Histories*, London, 1963.

P. Coates, *The Story of Flowers, Plants and Gardens through the Ages*, London, 1970.

W. A. Emboden, *Leonardo Da Vinci on Plants and Gardens*, London, 1987.

J. Gerard, *The Herball or General Historie of Plants*, London, 1597; enlarged 1636; facsimile edition, New York, 1975.

M. Grieve, *A Modern Herbal*, London, 1931; repr. 1976.

G. Grigson, *The Englishman's Flora*, London, 1958; repr. 1975.

M. L. Hairs, *The Flemish Flower Painters of the Seventeenth Century*, Brussels, 1955; English translation 1987.

E. Hardouin-Fugier and E. Grafe, *French Flower Painters of the Nineteenth Century*, London, 1989.

J. Harvey, *Early Gardening Catalogues*, London, 1972.

J. Harvey, *Medieval Gardens*, London, 1981.

P. Hobhouse, *Plants in Garden History*, London, 1992.

M. Levi d'Ancona, *The Garden of the Renaissance: Botanical Symbolism in Italian Painting*, Cambridge, Massachusetts, 1980.

P. Mitchell, *European Flower Painters*, London, 1973.

H. Oliver, 'John Rose's Pineapple' in *The Generous Garden*, ed. David Wheeler, London, 1991, pp. 78–86.

A. Paterson, *The History of the Rose*, London, 1983.

S. Segal, *Flowers and Nature: Netherlandish Flower Painting of Four Centuries*, exhibition catalogue, Osaka, Nabio Museum of Art, Tokyo, Station Gallery and Sydney, Art Gallery of New South Wales, 1990.

D. Stuart, *The Kitchen Garden: An Historical Guide to Traditional Crops*, London, 1984.

P. Taylor, *Dutch Flower Painting, 1600–1720*, New Haven and London, 1995.

P. Taylor, *Dutch Flower Painting 1600–1750*, exhibition catalogue, London, Dulwich Picture Gallery, 1996.